For everybody who has
ever taken pleasure in either
a cigarette or a cigarette packet

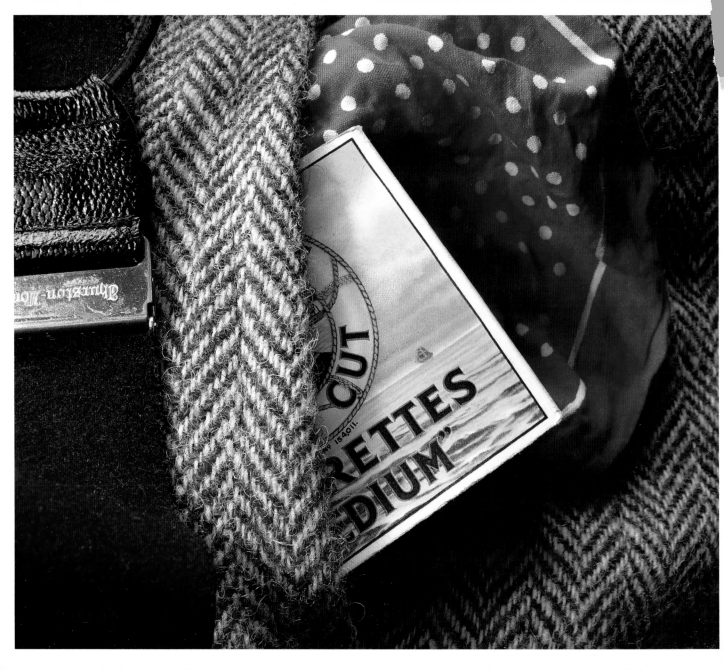

THE CIGARETTE PAPERS

Peter Ashley

F

FRANCES LINCOLN LIMITED
PUBLISHERS

Frances Lincoln Limited
4 Torriano Mews
Torriano Avenue
London NW5 2RZ
www.franceslincoln.com

First Frances Lincoln edition 2012
Published in association with Goldmark

Designed by Peter Ashley

A catalogue record for this book is available from the British Library.

978-0-7112-3357-7

Printed and bound in China

1 2 3 4 5 6 7 8 9

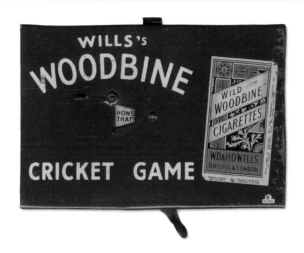

I know a bank where the wild thyme blows,
Where oxlips and the nodding violet grows,
Quite over-canopied with luscious woodbine...
A Midsummer's Night Dream William Shakespeare

Introduction

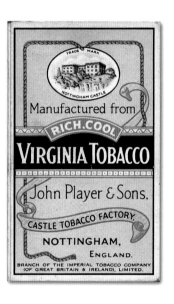

Once upon a time, everybody smoked cigarettes. My dad smoked drums of Player's he'd brought back from the war in one of those tall white canvas kit bags; the laundry man always had a Woodbine on the go and my Sunday School teacher lit up a Churchman's as soon as he came out of church. Hod carriers building the post-war boom scooted up ladders with a Park Drive firmly clamped in their mouths and conductors leaned on warm radiators at bus termini with a Capstan. Dad put his packet of twenty Player's up on his end of the mantelshelf, next to the big dark brown wireless set. He would look at me as he reached up for them, and I became spellbound as the wreaths of blue smoke magically curled up above his head as he tuned the wireless in for *Educating Archie* or *Variety Bandbox*. But it was the packet that fascinated me even more. The hirsute sailor sharing his life-belt with a naval history of sailing ships and smoky frigates, another ship in full sail and a lighthouse on a rocky promontory lit by a fiery sunset.
I couldn't read the words, didn't know that it said 'Hero' on his cap or that they named the cigarette factory after the castle that appeared on the cliff on the back of the packet.

These were the first cigarettes I saw. I also knew that four or five packets were hidden under the white linen tablecloths in the bottom draw of the bureau. What that was about I never knew. I didn't like to ask, perhaps my mother was a secret smoker in between doing the washing and boiling up tripe. But as soon as I'd mastered my orange tricycle I furiously pedalled down next door's drive to where a man in a green apron stood with his nicotine-stained fingers in little terracotta pots in a warm sunlit greenhouse. Always with a cigarette on, hanging off his bottom lip as he called out my name. And there, next to a trowel and bits of string, was another Player's packet.

Maybe they were the only ones you could get, I thought: a kind of post-war austerity generic fag. Until I started at school of course. Every playtime saw rubberbanded stacks of flat packs come out of grimy grey trouser pockets. A few were propped up against the wall, the rest were skimmed to knock them down like ducks at a fair. I think you got a double score if one dropped on another, a Paymaster falling on a Miss Blanche. We fought for them on the buses, diving and scuffling under the seats for a Gold Flake, nosing in waste bins for Passing Clouds. I particularly looked out for Bristol packets, because I cut the coat-of-arms off in order to stick them on the sides of my Dinky Toy buses. And the first try at smoking one? I was eleven, and it was a Will's Woodbine, handed round a circle of dirty-knee'd ruffians in a tarred barn. Self-righteously I took one drag and threw it down saying "Ugh. That's disgusting. How can anybody do that?" I remember the looks of disbelief as my pals fought each other to find it, but I don't remember what happened to the barn except it was pulled down a week later.

From then on it was a sporadic pastime. Black Russian Sobranies in the wings of the school's rendition of *Merrie England*, half Park Drives in the alleys at the side of pubs where half pints were surreptitiously passed to us by mates of mate's dads. Barely shaving I started work in a local public library and discovered Len Deighton books. So of course I had to go to London and hang around in cafés smoking Gauloises, watching black cabs in the rain whilst mini-skirted mascara'd girls giggled on adjoining formica tables. I bought the blue paper packets in one of the

7

capital's last surviving mid-eighteenth century bow-fronted shops, Fribourg and Treyer in Haymarket. I also pocketed F&T's own brand in a beautiful flip-top box in green and gold, just for the pose. I ostentatiously chuffed them on the train back home, leaving the pack where everyone could see it on top of my bag of books from Zwemmers. The teenage obsessions waned and I started to associate packs with certain friends. One who always got out his burgundy Dunhills and burnt a hole in our sofa, another with Gold Leafs he never passed round.

In 1975 I went to pick up a job at a big London advertising agency in Mornington Crescent, and a copywriter showed me a box of swaps from his cigarette packet collection. Such rich pickings – Player's Country Life in every size permutation, a perfect Mitchell's Golden Dawn and Robert Burns staring out from twenty Sweet Afton, mouthing "Go on, buy 'em." Only in an Ayrshire accent obviously. I did, for a fiver. Only later did I realise that my collection had been kick-started in the old Carreras Black Cat cigarette factory. But as I laid them out on my work table, vainly trying to stop other designers filching the ones

I wanted, I started to think: they really don't look like this anymore.

Long before high-minded bonkers government legislature, the cigarette industry had started to abandon any pretensions to art on their packets. Bland stripes and regulated coloured panels contrived to remove any vestige of individual identity from the packaging. "We're all global smokers now," they seemed to say, "Mothball those ships, cashier that sailor, straighten up that type soldier!" Some of the characters held on – Hero shrunk in his lifebelt over a navy stripe, the Black Cat that had been put out into Hampstead Road was later given a year or so of a tenth life. You could still buy your Senior Service or Will's Gold Flake in much the same hull and slide packets in obscure back street tobacconists, but in reality we knew it was all over. Ogden's Robins and Teals flew the nest for good, Turf's winged horse took off for Arcadia. Trumpeters fell silent, Anchors were pulled up, Kensitas' butler (does he remind you of Poirot?) firmly locked the green baize pantry door. Although, we didn't really appreciate just how bad it was going to get, with hectoring health warnings and colour

cut-out-'n'-keep photographs of wrecked lungs. Why not bring back cigarette cards inside the surgically surreal packs, I thought? *Incurable But Colourful Diseases You Can Get From These Fags. A Series of 50.*

By the time you read this, we may have lost pack design altogether. The government would like them to be either plain brown or grey, and not 'glitzy' as they say. The best bit is that they seriously believe that it will discourage smoking, and will 'protect' the kiddies from wanting to try it out. There is quite simply no proof whatsoever that plain packs will make any difference at all. Of course we all know that a distinct lack of evidence, scientific or otherwise, has never stopped them from banning anything they so self-righteously disapprove of.

So here they are, perhaps for the last time, reminding us of when we didn't have to feel guilty about having a packet of Rothmans in our pockets. Reminding us, whether we're smokers or not, of a time when it wasn't a subversive activity, when we didn't have to huddle on street corners in the rain. Anyone got a light?

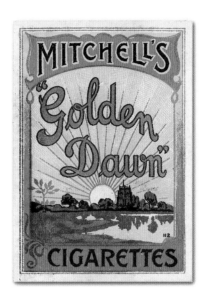

Tobacco is, of course, an agricultural crop. *Nicotiana* is the genus, nicotine the colour of pub ceilings. Sir Walter Raleigh is given the credit for introducing its recreational possibilities to the court of Elizabeth I in the 1580s, along with potatoes (not such a good smoke). Probably due to our strained relations with Spain, we were grateful for a new source of the crop growing copiously in the eponymous Virginia. So it's Raleigh's fault for all those Capstans I've set fire to. John Lennon once eloquently sang a line about Sir Walter and his tobacco influence on the Beatles' unnamed minimalist coloured album. I'd quote it for you but somebody wanted £450 for eighteen words.

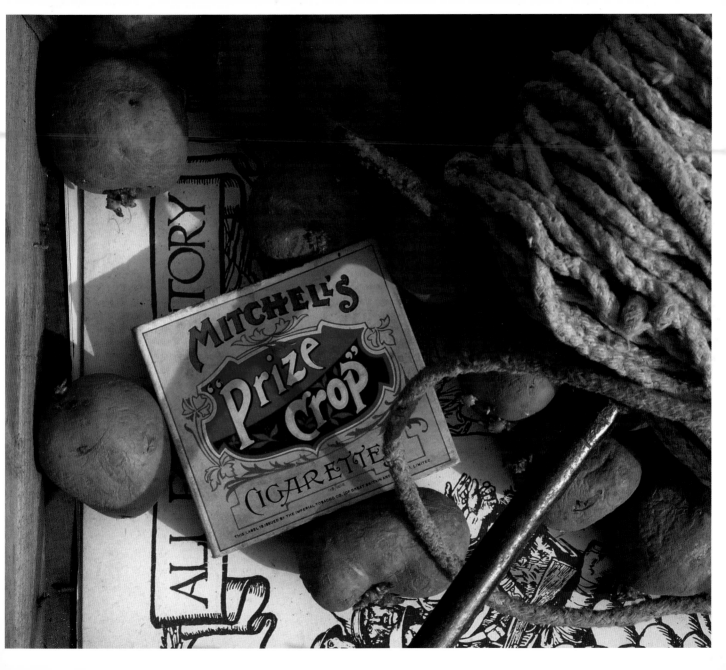

Being on the right side of England for the New World colonies, Bristol was superbly placed to take advantage of the tobacco trade. The quays were stacked high with wooden tobacco barrels, and although Charles I had attempted to restrict the import to London, by 1670 over half the ships unloading in Bristol were laden with tobacco. In the eighteenth century, being a tobacco merchant here must have been the thing-to-be, watching from a Clifton eyrie as tall-masted ships negotiated the mud and tides of the Avon Gorge into the quaysides at the heart of the city. A trade culminating in the vast pink brick Wills factory in Bedminster. All gone now, but at least one tobacco factory in Bristol has a new life – as the Tobacco Factory Theatre.

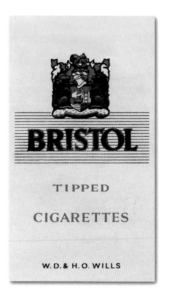

BRISTOL

TIPPED

CIGARETTES

W. D. & H. O. WILLS

BUILDINGS
OF
ENGLAND

NORTH SOMERSET
AND BRISTOL

CLIFTON
SPECIAL CUT
Cigarettes

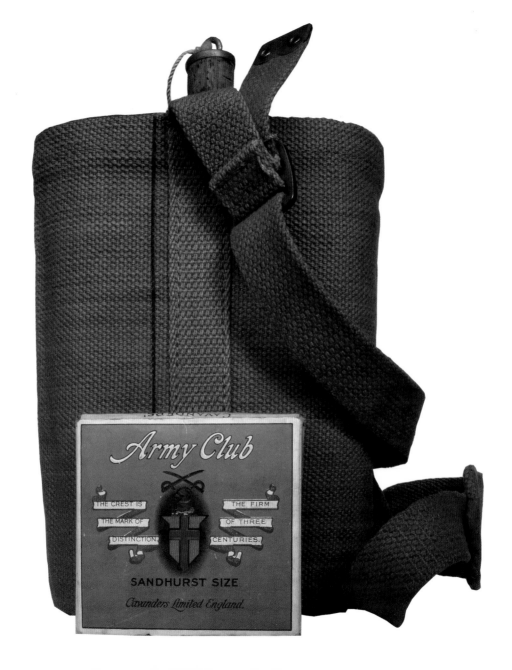

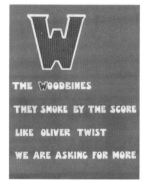

THE WOODBINES

THEY SMOKE BY THE SCORE

LIKE OLIVER TWIST

WE ARE ASKING FOR MORE

War has always sent soldiers to the front of the cigarette queue. The blokey camaraderie, the testosterone-fuelled culture and the need for steadier nerves made just about everyone reach into serge pockets for the comforting packet of fags. The Reverend Andrew Clark of Great Leighs in Essex wrote in his diary of January 1917 "One indirect result of war has been an enormous increase in cigarette smoking, both among ladies and lads. This began before the war but the examples of officers and men, who are continually smoking cigarettes, has given it great impulse." In November 1914 Princess Mary, the seventeen-year-old daughter of the King and Queen, created a Sailors & Soldiers Christmas Fund which raised enough money to distribute 355,000 brass tins of tobacco and cigarettes to everyone in uniform serving overseas, by the Christmas deadline. The goodies were wrapped in yellow monogrammed wrappers, but if you didn't smoke you got a bullet-shaped pencil (subtle) and sweets. Nurses got chocolate.

When they had finished all there was of both food and drink, he produced a packet of Gold Flake cigarettes, and they smoked for a while, contented and at rest. But the larks had come down. The cold wind rendered their exultation intermittent. *A Glastonbury Romance* John Cowper Powys 1933

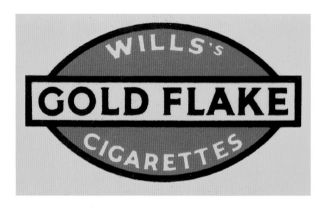

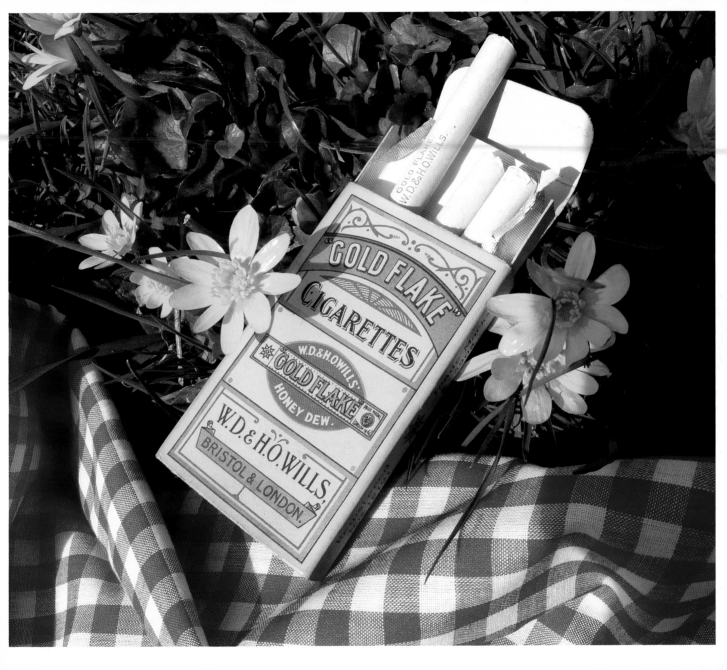

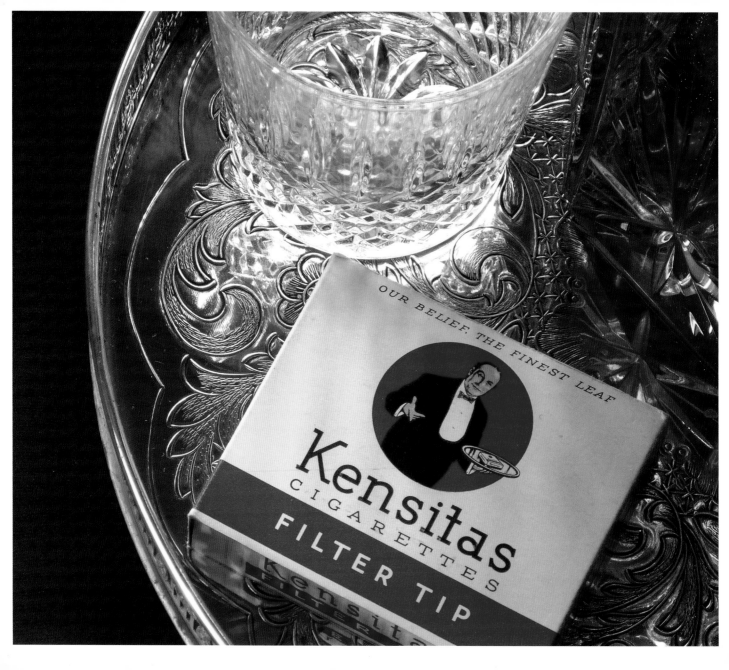

Two Player's cigarettes were walking down the street and came across two Woodbines crying their eyes out. "What's the matter," they enquired. "Kensitas," they replied through their tears. And that was how I came to hear of the brand, famous for its dutiful butler, apparently called 'Jenkyn', and the silk pictures of flowers they produced between 1933-4, probably the most beautiful in-pack promotion ever devised.

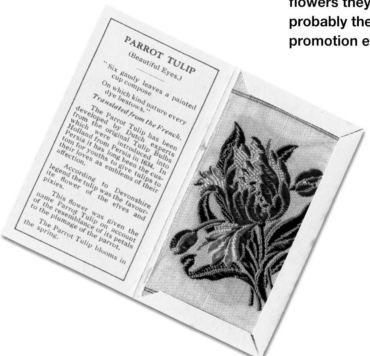

PARROT TULIP
(Beautiful Eyes.)

" Six gaudy leaves a painted cup compose
On which kind nature every dye bestows."
Translated from the French.

The Parrot Tulip has been developed by Dutch experts from the original Tulip Bulbs which were introduced into Holland from Persia in 1634. In Persia it has long been the custom for youths to give tulips to their loves as emblems of their affection.

According to Devonshire legend the tulip was the favourite flower of the elves and pixies.

This flower was given the name Parrot Tulip on account of the resemblance of its petals to the plumage of the parrot.

The Parrot Tulip blooms in the spring.

In 2003 a Sweet Afton packet was discovered balanced on a beam above the altar of Islandeady church in County Mayo, put up there by three decorators. They left this message written on it: "Please say a wee prayer for the painters – Tommy Brett, Jim Devaney, John Joe Brett – who painted Islandeady church in June and July 1954. Please say one – we may need them – J.J. Brett."

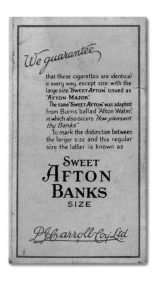

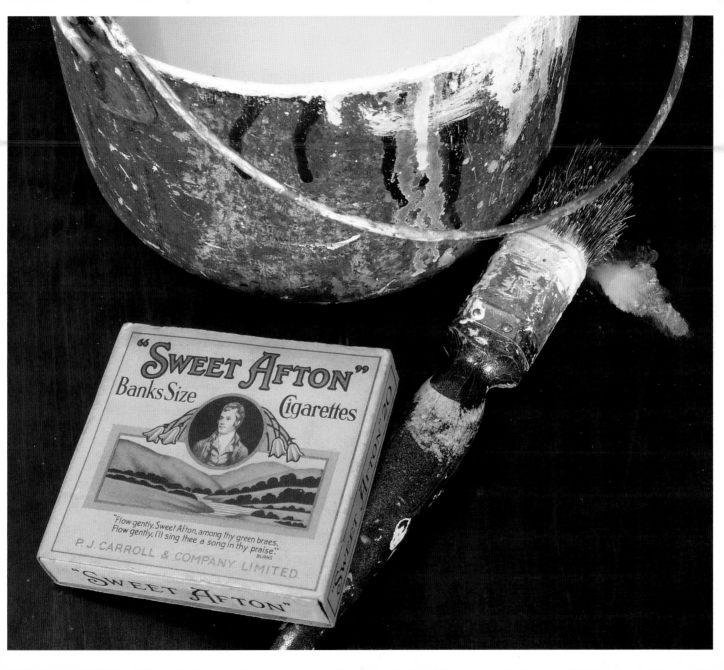

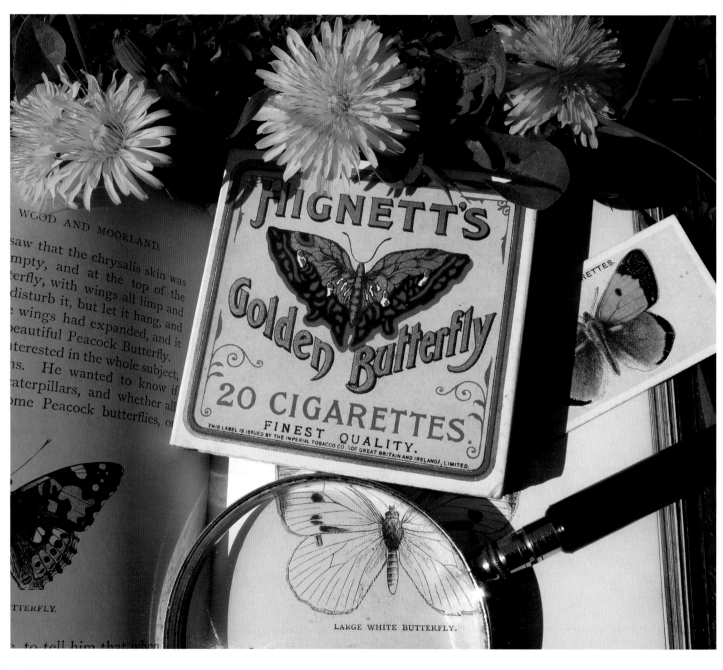

Sometime in 1974 I acquired this beautiful Hignett's Golden Butterfly packet. Hignett's were based in Liverpool, but a scion of the family lived near my home in Leicestershire. I had never met Colonel Hignett, so we were pleased to receive an invitation to a wedding that was to be celebrated at his home, kindly lent for the occasion. As we queued on the grand steps that led up to the front door to be presented to the wedding party, we were greeted by a stately-looking man in black tails and pinstriped trousers. "Colonel Hignett," I spluttered, "how splendid to meet you. I have one of your cigarette packets in my collection, Golden Butterfly, probably circa 1910," and he leant forward and whispered in my ear "Very interesting sir, but I'm the butler." I went as pink as the packet in embarrassment.

Was there ever an actual Black Cat? Of course there was. He might even be the one whose photograph appeared on early packets, the cat who padded about Carreras' Wardour Street premises. Which quickly became known as the Black Cat Shop. So indelibly was this lucky charm associated with the firm, cats appeared as Egyptian-style sentinels and fascia details outside their new 1928 Arcadia Works in Mornington Crescent, London (below). Hitler was so impressed with it he optimistically earmarked it as his Third Reich headquarters. Germania in Camden. But the Black Cat did sterling service for Carreras' brands. He managed football competitions, fundraisers and doubtless twitched his whiskers with pleasure at seeing Carreras' reps dressed-up in cat suits.

 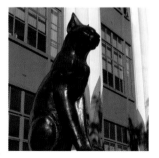

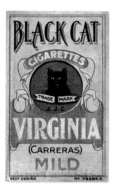

BLACK CAT
CIGARETTES
TRADE MARK
J.J.C.
VIRGINIA
(CARRERAS)
MILD
REGD DESIGN Nº 45564 A

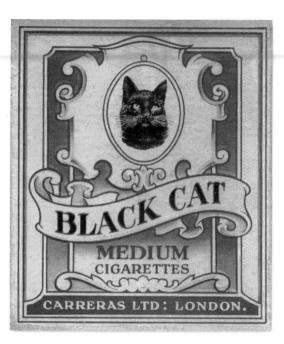

BLACK CAT
MEDIUM
CIGARETTES
CARRERAS LTD: LONDON.

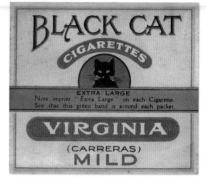

BLACK CAT
CIGARETTES
EXTRA LARGE
Note imprint "Extra Large" on each Cigarette.
See that this green band is around each packet.
VIRGINIA
(CARRERAS)
MILD

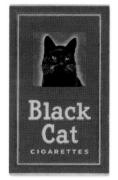

Black
Cat
CIGARETTES

Now, as we near the ocean roar,
A smell of deep-fry haunts the shore.
In pools beyond the reach of tides
The Senior Service carton glides,
And on the sand the surf-line lisps
With wrappings of potato crisps
Delectable Duchy John Betjeman

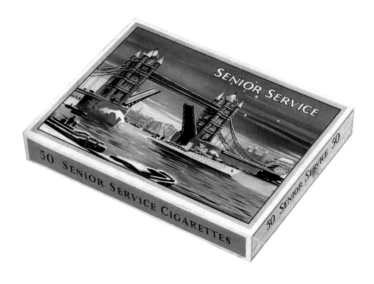

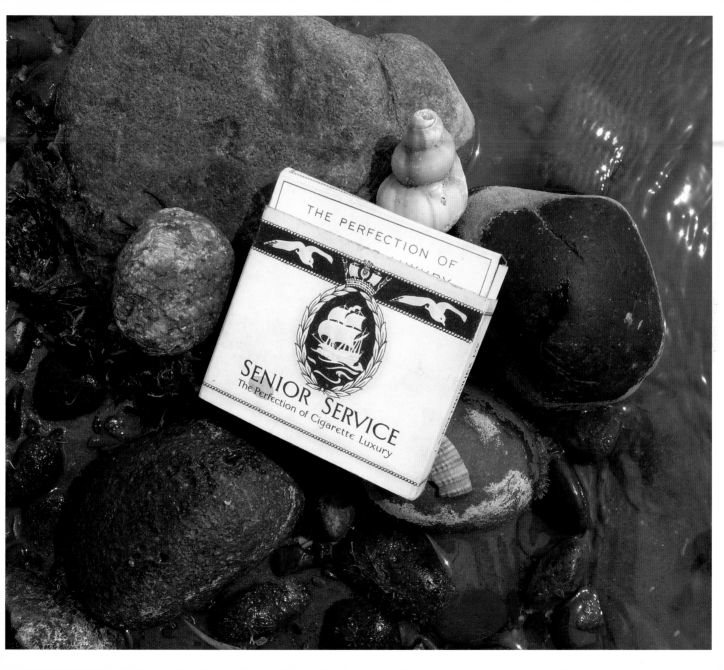

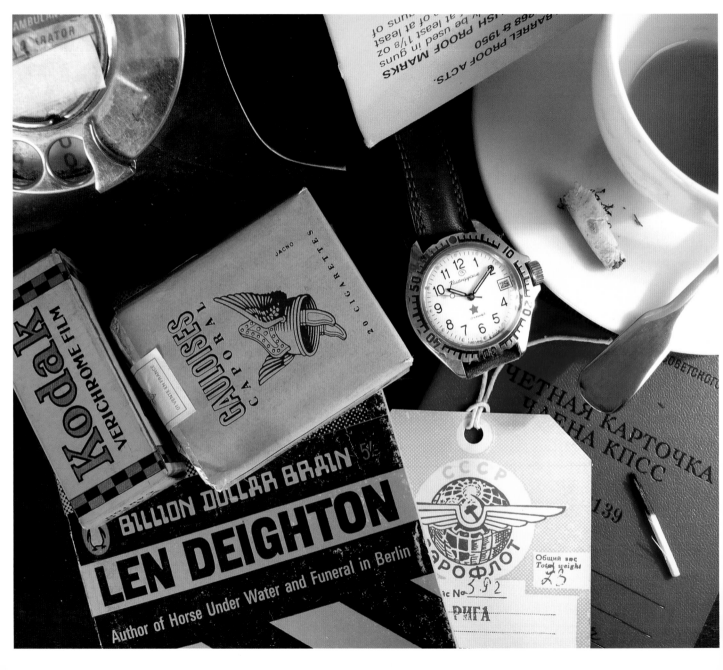

"Just tell me the whole story in your own words, old chap. Smoke?" I was wondering whose words I might otherwise have used as he skimmed the aspidistra with his slim gold cigarette case. I beat him to the draw with a crumpled packet of Gauloises;
I didn't know where to begin. "I don't know where to begin," I said.
The Ipcress File Len Deighton 1962

"…Give me that pistol." He raised it; the young bony hand was steady as a rock: he put six shots inside the bull. "That's worth a prize," he said. "You can take your bloody prize," Bill said, "and hop it. What do you want? Chocolates?" "I don't eat chocolates," the Boy said. "Packet of Players?" "I don't smoke." "You'll have to have a doll then or a glass vase."

Brighton Rock Graham Greene 1938

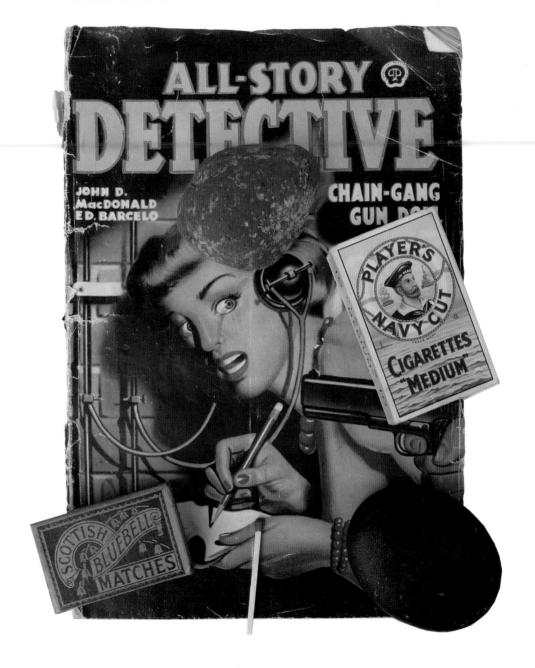

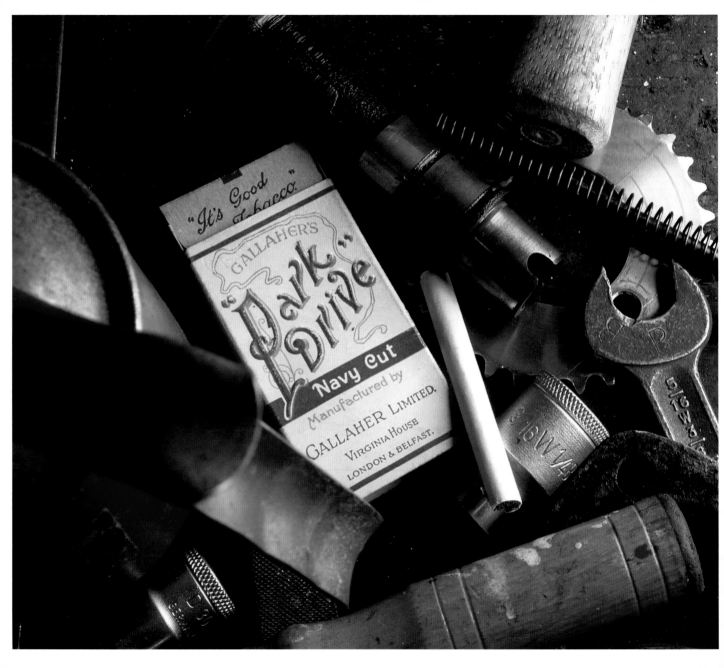

Park Drive were Thomas Gallaher's response, in 1897, to the popularity of Woodbines. Cigarette Land had quirky regional preferences, and cheapo Park Drives were taken up as the fag-of-choice by the men of the Midlands. The brand is therefore probably the most likely one to be found discarded under dusty floorboards in Leicester.

My introduction to them came on my first day as a nervous junior in a commercial art studio in that same city. For a few days the formidable character at the desk opposite eyed me suspiciously through blue skeins of Park Drive smoke. Everytime he finished a job he would stand up, swear, light a 'Parkie' with a Zippo and stare out of the window, the fag covertly cupped in his brush hand. My impressionable mind found it all impossibly cool.

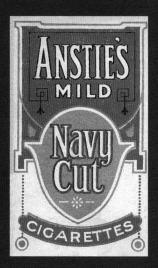

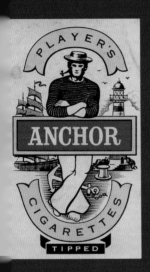

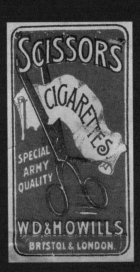

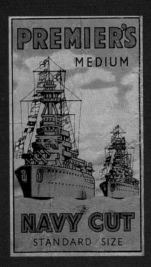

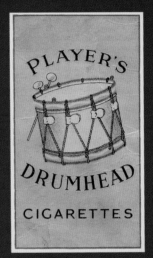

The way it's going, you soon won't be able to smoke in your own home. (Despite the fact that the government takes around £10 billion a year in tobacco tax*.) So smoking is now even more resolutely an outdoor activity, as seen by the *al fresco* canopies and ashtrays provided by town and country pubs alike. It was ever thus; the tobacco industry was keen to associate their products with open air activity. Player's Country Life crammed it all in – rowing, cricket and cycling on the front; horseriding, golf, fishing, open-topped motoring on the back. A whole aviary flapped in elsewhere – the seagull soared onto the Senior Service pack, Ogden's fancied the Robin and Teal and Gallaher's gave us the brilliantly exotic Three Birds.

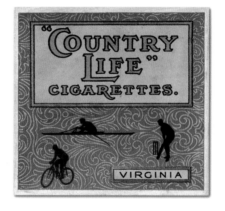

*Source: HM Revenue & Customs / TMA

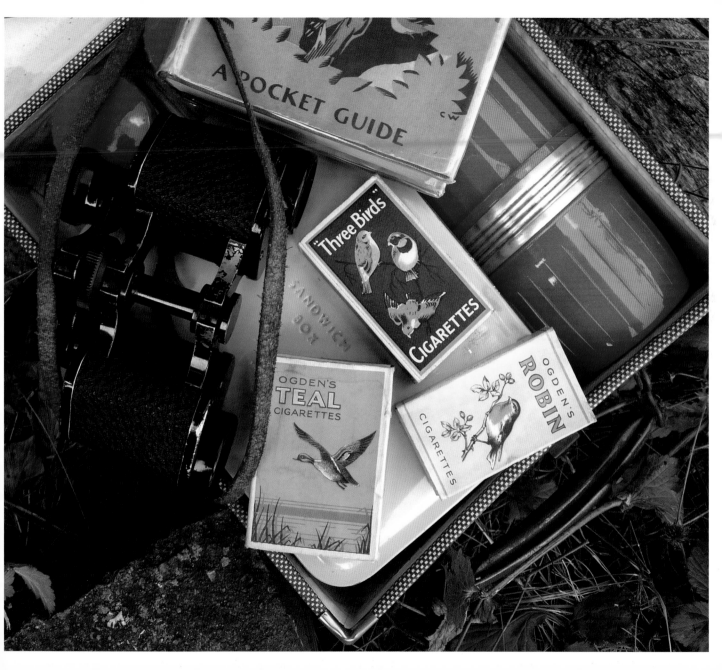

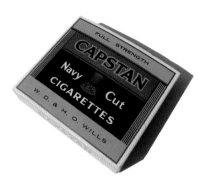

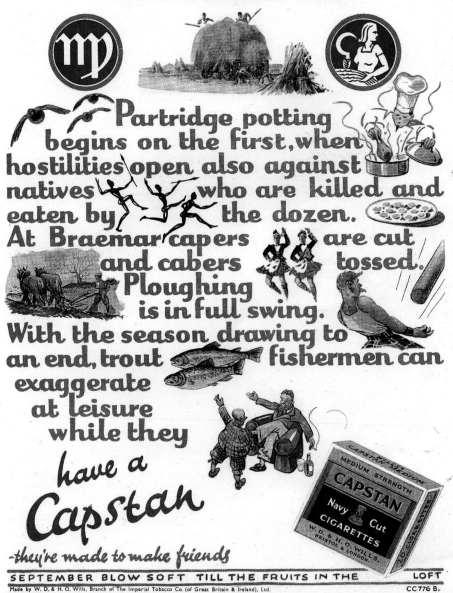

SEPTEMBER

Partridge potting begins on the first, when hostilities open also against natives who are killed and eaten by the dozen. At Braemar capers are cut and cabers tossed. Ploughing is in full swing. With the season drawing to an end, trout fishermen can exaggerate at leisure while they

have a

Capstan

—they're made to make friends

SEPTEMBER BLOW SOFT TILL THE FRUITS IN THE LOFT

Made by W. D. & H. O. Wills, Branch of The Imperial Tobacco Co. (of Great Britain & Ireland), Ltd.

CC 776 B.

CAPSTAN Navy Cut CIGARETTES W. D. & H. O. WILLS

In the days when you could chuff away in pubs with impunity, I once caught sight of a very old lady with twenty Capstan Full Strength next to her port 'n' lemon. The landlord saw me staring at her admiringly as she lit up one of the last in the packet and mouthed "She's ninety". There was no pussyfooting around with these Capstans. No filters, no 'extra lite', these were industrial strength; and if more than one person lit up a Capstan on the top deck of a bus you couldn't see from one end to the other.

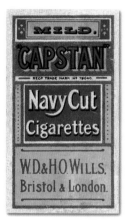
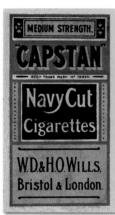
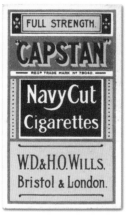

The sea and cigarettes were once inseparable. It must have started with the seventeenth-century tobacco trade between the Americas and Europe, but it was in the Royal Navy that sailors bought whole tobacco leaves which they bound up with rope into a tightly compressed roll. They would then slice what they needed from the end, 'Navy Cut', the shredded tobacco being used in pipes and then rolled up into cigarettes. The imagery is perfect: a rollicking life on the ocean wave, weather-beaten heros and plenty of salty fresh air. No other association with tobacco has had such a rich variety of nomenclature and design. The Royal Navy get their cigarettes duty free, hopefully still in the no-nonsense, beautifully utilitarian pack.

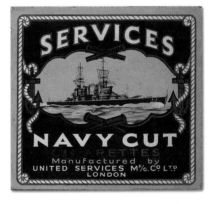

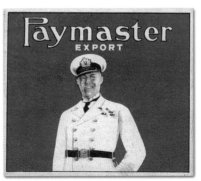

...he reached down into his hip pocket and took out a wide, thin gunmetal case and opened it. "Have one? Senior Service. I suppose it'll have to be Chesterfields from now on." His mouth turned slightly down as he smiled.

The Spy Who Loved Me Ian Fleming 1962

The dark-eyed Dolobowski went for some more ice from the fridge. Skip produced one of those vast cartons of cigarettes and talked Jean into trying a Lucky. He lit Jean's, and the dark-eyed one gave us more ice and Scotch all round. *The Ipcress File* Len Deighton 1962

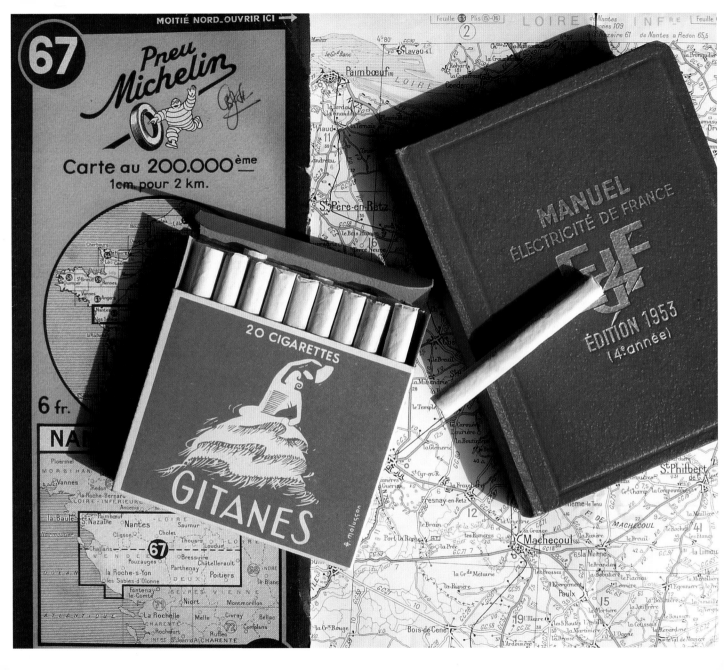

David Bowie and John Lennon smoked them in the 1970s, but these cigarettes, with a gypsy woman – *gitanes* – dancing across the pack, are as French as the tricolour. Along with black Maigret Citroens and yellow Ricard ash trays, this blue packet allied you to all things *français*. They were an acquired taste (a friend says it's 'Africa'), but Gitanes put you at a zinc bar drinking with workers in *bleu de travail*, even though their preference would probably have been for Gauloises. We like to think of them clasped permanently in the drooping Gallic mouths of *camion* drivers, but with typical French *egalité* they could equally be found being lit up in a Facel Vega by Albert Camus. What happened? France has all but abandoned them, not because they've gone off smoking (*mon dieu!*) but because they're all smoking Marlboro Lights. Only one factory's still open, and that's in the Netherlands along with HP Sauce. *Sacre bleu*!

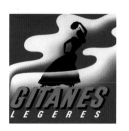

The richly-coloured world of cigarette cards started life as inserts used as stiffeners in paper packets. Allen & Ginter of Richmond, Virginia lay claim to the first ever set in 1875, and since then there have been cards on everything from Thackeray to First Aid, Gardening Hints to Air Raid Precautions. What a brilliant way to insure brand loyalty. The world's largest collection is that of Edward Wharton-Tigar, bequeathed to the British Museum in 1995. Amongst the rarest are Taddy's Clowns and Circus Artistes, and the world record price for a single card is (opens gold envelope) £1,200,000.

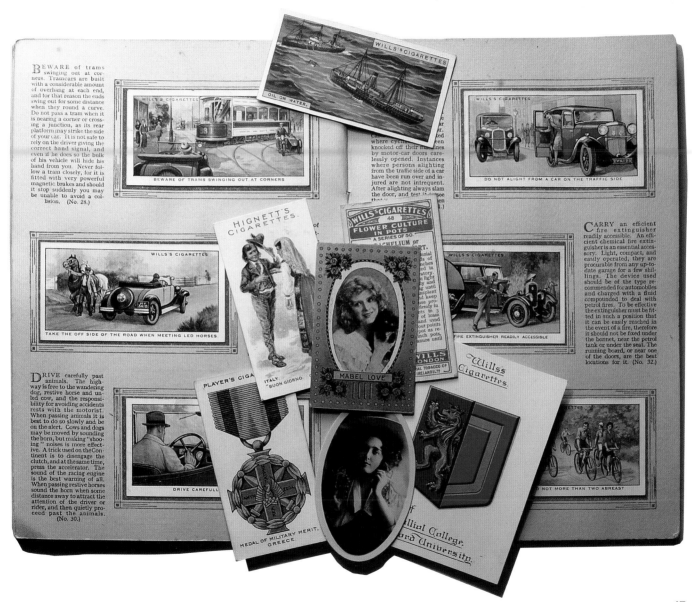

An idea on the back of a cigarette packet, the instant notebook for that great lightbulb moment. Did Alec Issigonis do the Mini on one? The interior slide of a Churchman's No.1 packet provided a space specifically for jotting and drawing, and, in a delightful progression, a fold-out notebook apparently for cricket scoring. Churchman's were always so helpful – they put 'front' on the front, and, like many other manufacturers, put raised blind embossed lettering on the base of the slide so that you knew the right way up your fags were in the cinema, or the blackout. Value-added we say now.

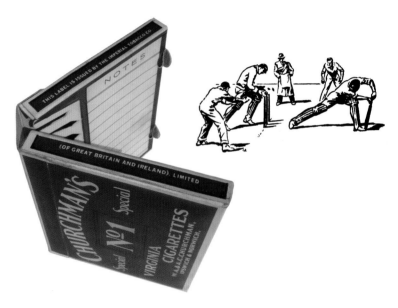

A CHRISTMAS TREE

EX UNITATE VIRES

SOUTH AFRICA

TELEGRAPH WIRES.

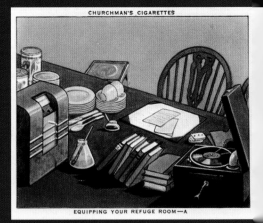

EQUIPPING YOUR REFUGE ROOM—A

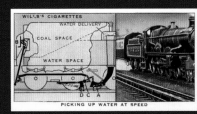

WATER DELIVERY

COAL SPACE

WATER SPACE

D C A

PICKING UP WATER AT SPEED

A "SPRING" CHICKEN

A MOCKING-BIRD.

A COMET.

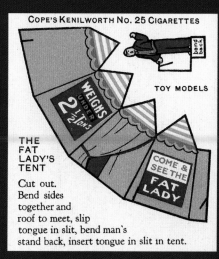

COPE'S KENILWORTH No. 25 CIGARETTES

TOY MODELS

THE FAT LADY'S TENT

Cut out.
Bend sides
together and
roof to meet, slip
tongue in slit, bend man's
stand back, insert tongue in slit in tent.

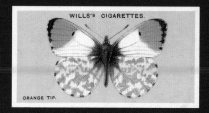

WILL'S CIGARETTES.

ORANGE TIP.

WILLS'S CIGARETTES

CORRECTING A SKID

WILLS'S CIGARETTES.

SAFETY - MATCHES.

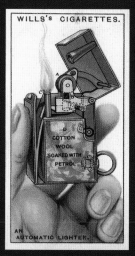

WILLS'S CIGARETTES.

AN AUTOMATIC LIGHTER.

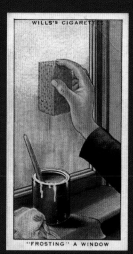

WILLS'S CIGARETTES

"FROSTING" A WINDOW

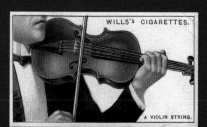

WILLS'S CIGARETTES.

A VIOLIN STRING.

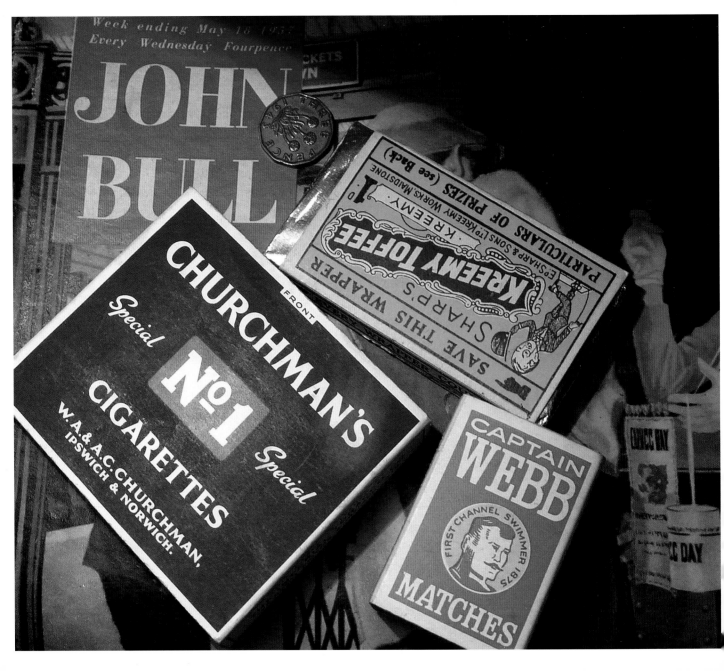

"See him?" Mrs Angel leaned her negligible bosom out over the magazines to watch him go. "Been hanging about here off and on these last several months. Him and some other fellows. Smokes Churchman's. Not my smoke, but it takes all kinds." *The Heart of London* Monica Dickens 1961

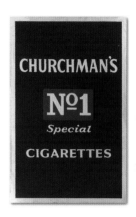

On the packed dance floor, near the bandstand, there was a small arena of space where Stamp and Rita, gyrating dangerously, were working out a dance of their own invention. They were both looking down at the floor to see what their feet were doing. "Yes?" said Liz. "Stamp calls you Woodbine Lizzie," I said. "You should hear what I call Stamp," said Liz. *Billy Liar* Keith Waterhouse 1959

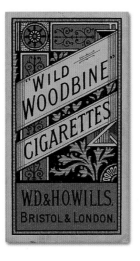

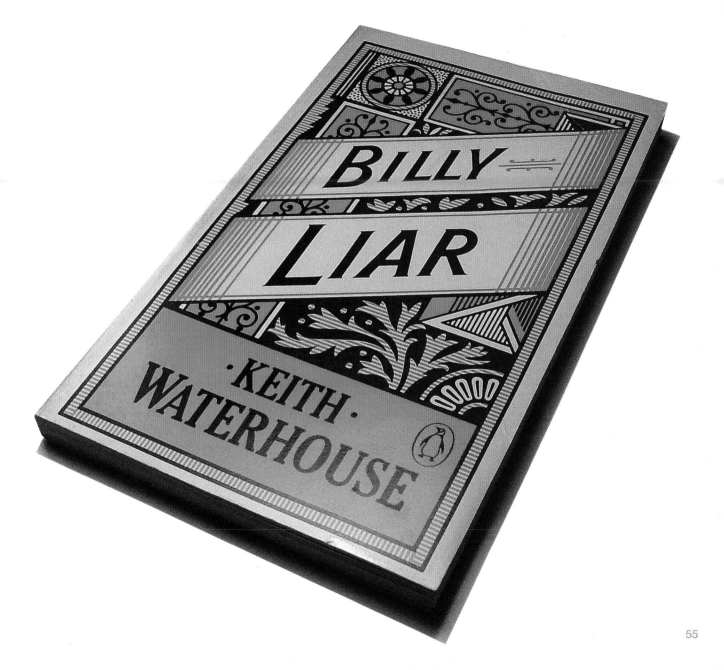

BILLY
LIAR

·KEITH·
WATERHOUSE

The origins of classic pack design are often shrouded in the drifting blue smoke of legend. Which has it that the original Player's sailor was Thomas Huntley Wood, who served on HMS Edinburgh in the 1880s. Did he become a landlubber on the proceeds? Hardly. Thomas got just a few guineas and some Player's tobacco for his pipe.

With Nottingham Castle on the back of the packet I always entertained the thought that characters in D.H. Lawrence's novels must smoke them when not being sons and lovers. And so entrenched in the national consciousness was the image of a packet of twenty Player's, the then wife of Procol Harum's lyricist Keith Reid ('all hands on deck'), repainted it for the cover of their 1969 album *A Salty Dog*.

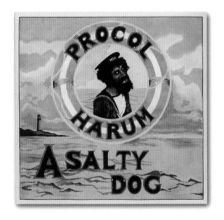

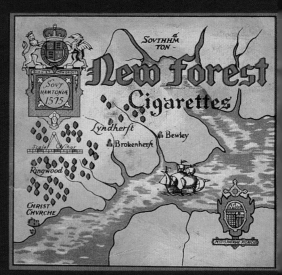

12 O'CLOCK CIGARETTES

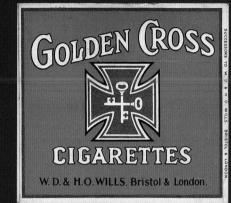

GOLDEN CROSS CIGARETTES

W. D. & H. O. WILLS, Bristol & London.

SUCCESSORS TO W. D. & H. O. WILLS, BRISTOL & LONDON.

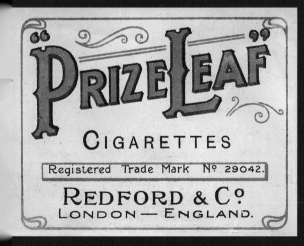

"PRIZE LEAF" CIGARETTES

Registered Trade Mark No 29042.

REDFORD & Co. LONDON — ENGLAND.

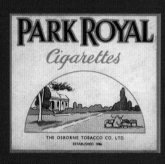

PARK ROYAL Cigarettes

THE OSBORNE TOBACCO CO. LTD.
ESTABLISHED 1886

Confronted by the last Sovereign disappearing at three in the morning after a dinner party, a guest glanced up at the glass case where I keep the prize items in my pack collection. "Any of those got any in?" he asked. "Don't even think about it," I said. And then we opened the big glass door and lifted out a Second World War economy paper packet of Wild Woodbine. We carefully slid a craft knife under the closure and removed a couple. Firm, clean, unblemished, we may as well have smoked a pair of shredded Air Raid Warden's trousers.

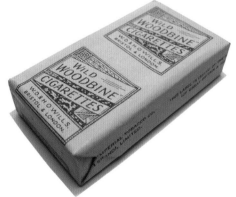

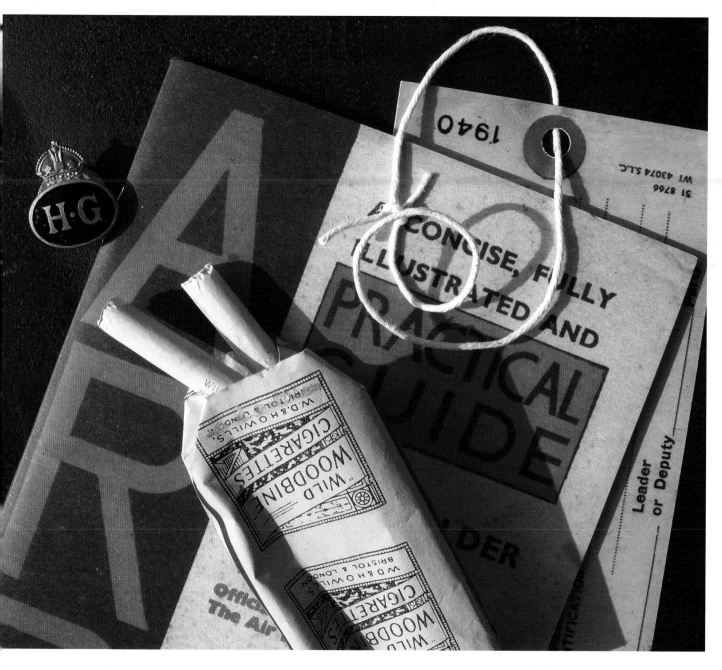

Katie came in and told me that a couple who had had tea wanted to stay the night. I asked her if they were married, and she said "the very pretty slip of a girl" had a ring, but as *she* had asked *him* whether he liked Player's or Wills' cigarettes, and *he* had asked *her* if she took China or Indian tea, and as he first asked for a room, and then rooms, and then for a room with a double bed, she didn't think they were married. They stayed on for dinner, saying no more about rooms. *An Innkeeper's Diary* John Fothergill 1931

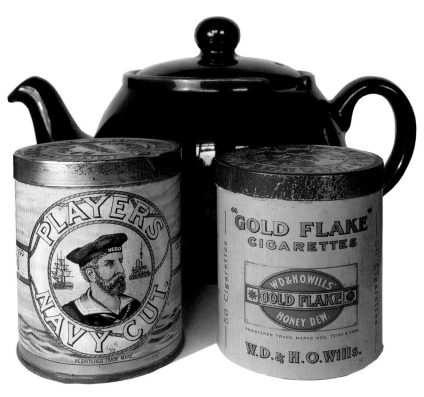

"There's no sweeter Tobacco comes from Virginia and no better brand than the 'Three Castles'." *The Virginians* William Makepeace Thackeray 1857-59. Thackeray made the name up, and Wills adopted it later.

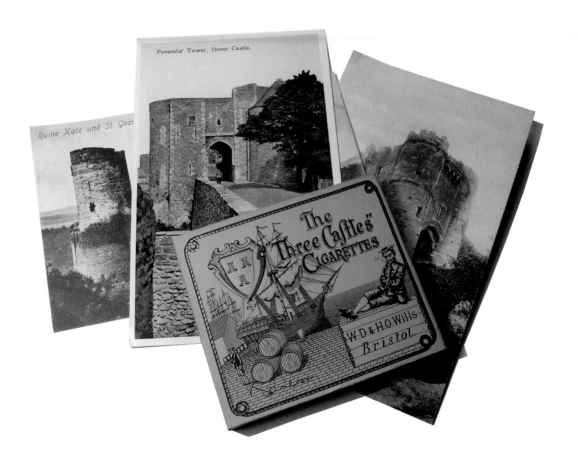

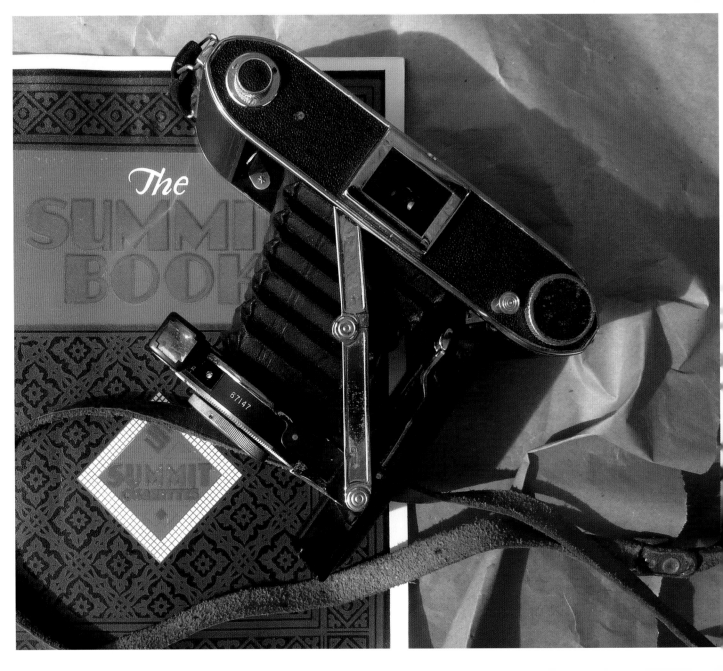

One sure-fire way of keeping brand loyalty was the cigarette coupon. Well known in Kensitas and Wills Star packets, the idea was simple. It was just like collecting Green Shield Stamps; you kept on smoking until you had enough coupons for a meat mincer or a wireless valve. Summit, who made a big thing of having a 'quality award' from the Institute of Hygiene, produced a very up-market catalogue that showed up-market 1920s people enjoying their 'free' gifts. A Decca wind-up gramophone for 300 coupons (or 'certificates' as Summit preferred to call them), a Tri-Ang pedal car for the young 'un for 500. An Ensign camera like the one opposite was 300.

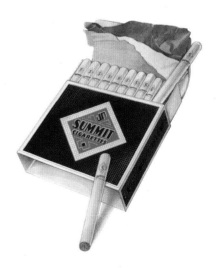

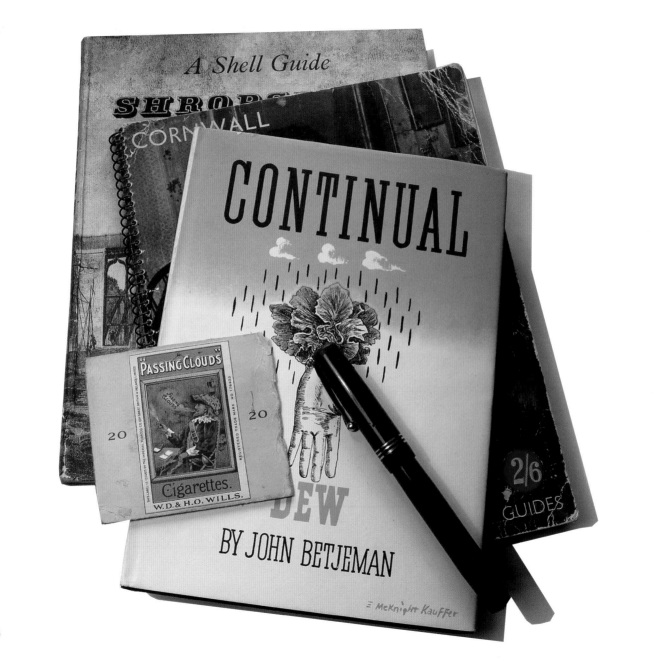

JB [John Betjeman] wrote his poems in a quiet room shut off from the world... He would write two or four lines and build them up, usually on the backs of envelopes, on flattened cigarette packets and on blank pages in his tiny pocket diaries ... JB smoked Passing Cloud cigarettes, which came in a pink packet. *John Betjeman Letters Volume One: 1926-1951* Edited and Introduced by Candida Lycett Green 1994

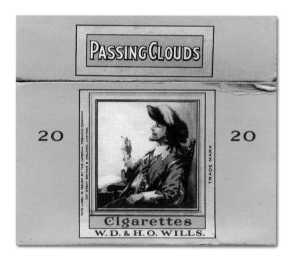

Time and long memories have forged a carapace of anecdote around the fighter pilots who fought the Battle of Britain in the summer and autumn of 1940. I don't know if this was a regular practice, but there are tales of pilots sliding open the plexiglass canopies of Spitfires and Hurricanes in order to throw their packets of Weights after German planes they had just shot out of action.

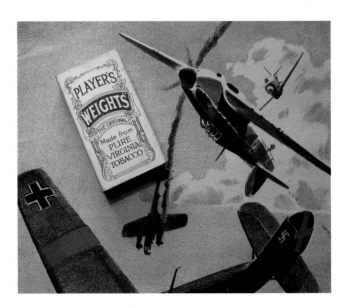

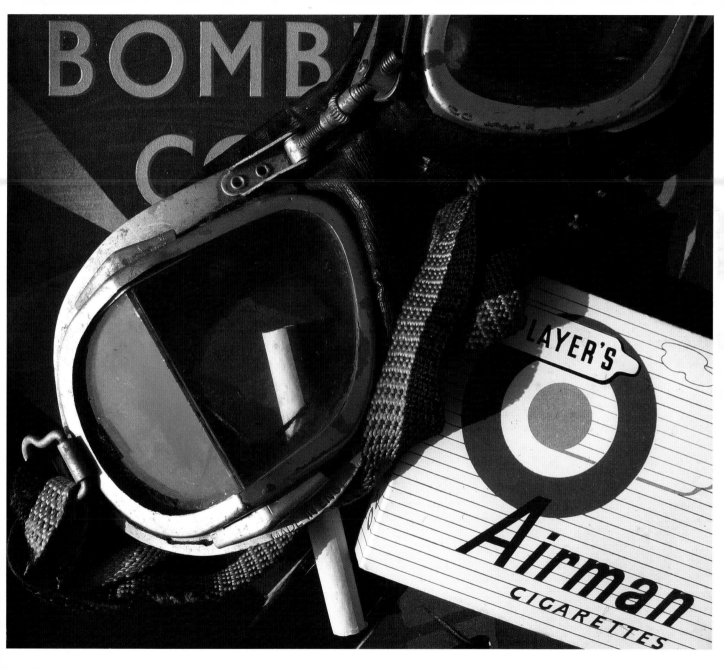

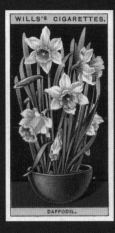

WILLS'S CIGARETTES.

DAFFODIL.

Player's Cigarettes.

Dr Portman. Pendennis.

WILLS'S CIGARETTES.

COMPRESSION OF BRACHIAL ARTERY BY FORCIBLE FLEXION

FLORA LE BRETON

C·W·S· TOBACCO FACTORY

APRICOT COMPOTE

Master Carr

The Motorist's Son.

NORTH WALES

SLATE QUARRYING

PLAYER'S CIGARETTES.

22ND CORPS.

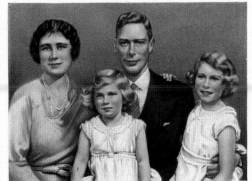

THE ROYAL FAMILY

CHURCHMAN'S CIGARETTES.

BLYTHBURGH.

WILLS'S CIGARETTES.

MIDLAND RAILWAY TANK ENGINE.

AERIAL (OUTDOOR)

GALLAHER'S CIGARETTES.

ANDREW AITKEN,
LEICESTER FOSSE, 1909-10.

HIGNETT'S CIGARETTES.

SWITZERLAND.
"BON JOUR. COMMENT
ALLEZ-VOUS?"

REGTL.
COLOUR. PLAYER'S CIGARETTES.

IV

CAP BADGE.

4th Batt. Oxfordshire & Buckinghamshire Lt. Infantry.

Two packets for one, this is an all-time favourite from the unpronounceable J.A. Pattreliouex. In 1983 I went for an interview in an agency in Queens Park, and arrived in London far too early. So I went round to Liz Farrow's shop Dodo in Westbourne Grove and bought this packet. Robert Opie, our foremost packaging archivist, was in there chatting her up. I then went and sat in Paddington Cemetery. "So where have you been?" asked the chairman as the opening gambit in my interview. "Well," I replied, "I sat in a cemetery and I bought this Trawler packet". I still got the job.

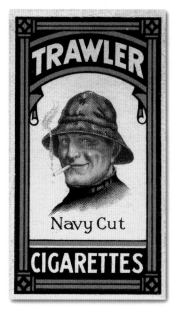

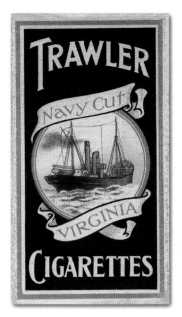

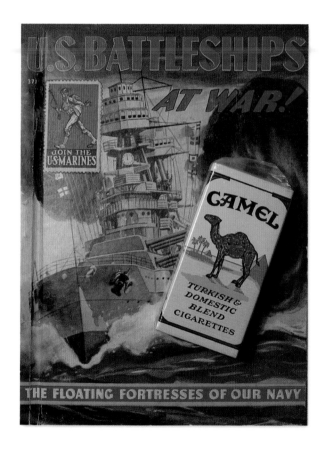

As I got my feet under the table in this new employment, my many and varied predilictions became widely known in the agency. One day an account man came down to the studio and told me that in his younger days he had travelled around America photographing everything in sight, and had been allowed on a US navy ship that had been mothballed. Down in the stores of untouched supplies he spotted a bulk carton of Camel cigarettes. His guide told him to help himself. "So I suppose you ought to have one" the account man said, bringing this packet out of his pocket.

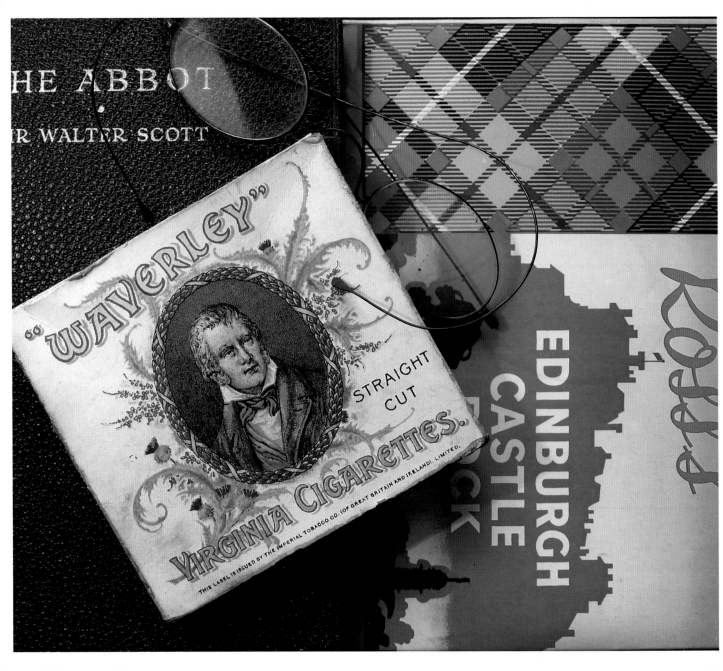

Sir Walter Scott's novels were once phenomenally popular. Not all his books are set in Scotland, but those that were kicked-off the Victorian tourist's idea of Highland folk, even though Scott himself lived down in the Lowlands. All that tartan and shortbread, blame him. Edinburgh so loved their scribe they put up a huge canopied statue to him on Princes Street, and much later his still familiar image was taken up by Sassenachs Lambert & Butler to bring a bit of class to their packets of Waverley, named after his first novel. As is Edinburgh's main railway station.

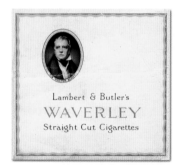

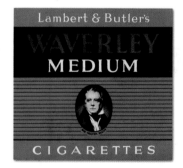

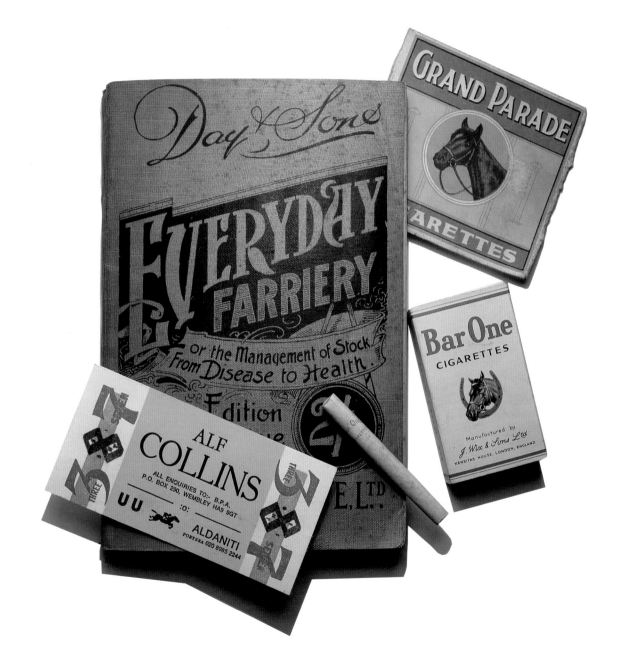

Horses have always been closely associated with man's activities. It's only comparatively recently that they were the main method of getting around and transporting goods. So it's not surprising that they crop-up on cigarette packets. There's always been the ceremonial – the steady Trumpeter horse; the classical – Pegasus flying out from a packet of Turf. But once the railways and roads could bring increasing numbers to the racetrack, the horse became a symbol of good luck (hopefully) in the 3.15 at Newbury. Gone now the fug of the bookies, vanished the monocled racegoer stubbing out a Bar One as he crossed another loser off his race card. The joke about Bar One was that people said you shouldn't buy them because they were always one short.

Heraldic devices were eagerly put to use by pack designers. Army Club made their armorial bearings look like battle honours, the scrollwork merely being a puff for the brand, while the Royal Scots Greys had a packet all to themselves, complete with their moments of distinction emblazoned on the sides. But flags were something else. Seemingly innocuous, they quickly had to be modified when anti-British sentiments abroad in the 1920s meant that outraged smokers ritually burnt flag-bearing packets in market places. "Buy your highly combustible flags and Redford's Navy Cut here!"

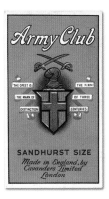

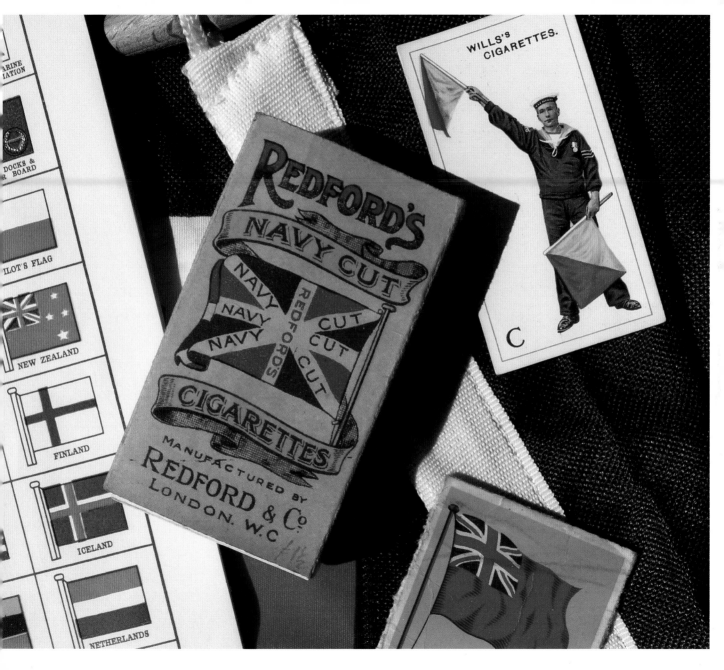

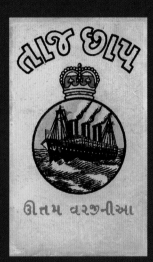

તાજ છાપ

ઊત્તમ વરજીનીઆ

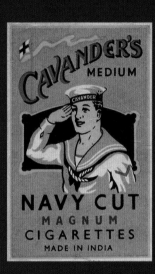

CAVANDER'S MEDIUM

NAVY CUT

MAGNUM

CIGARETTES

MADE IN INDIA

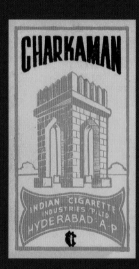

CHARKAMAN

INDIAN CIGARETTE
INDUSTRIES (P.) LTD
HYDERABAD · A·P

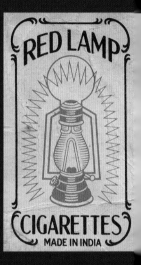

RED LAMP

CIGARETTES

MADE IN INDIA

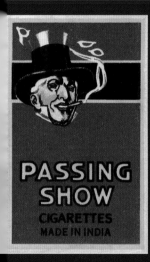

PASSING
SHOW
CIGARETTES
MADE IN INDIA

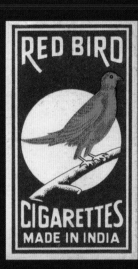

RED BIRD
CIGARETTES
MADE IN INDIA

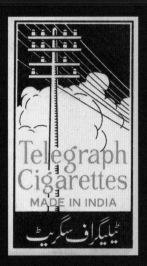

Telegraph
Cigarettes
MADE IN INDIA

ٹیلیگراف سگریٹ

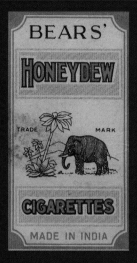

BEARS'
HONEYDEW
TRADE MARK
CIGARETTES
MADE IN INDIA

**Miles of pram in the wind and Pam in the gorse track,
Coco-nut smell of the broom, and a packet of Weights
Press'd in the sand.**

Pot Pourri in a Surrey Garden
John Betjeman

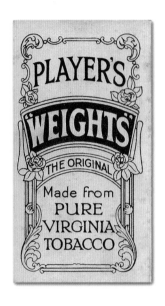

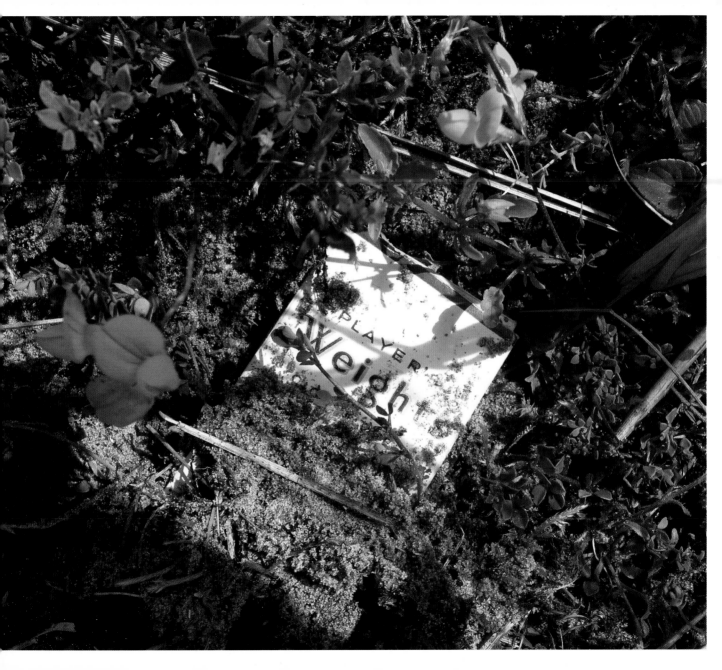

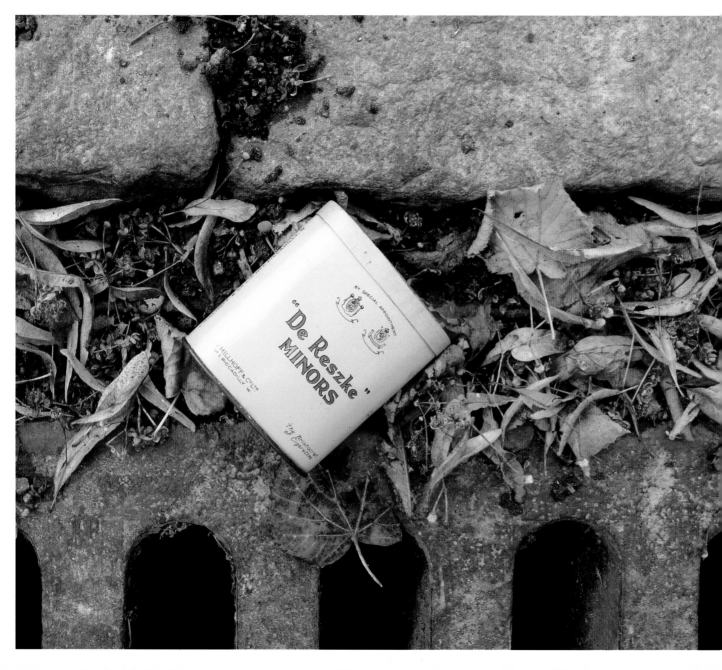

Apart from dropping bombs all over London during the Blitz, Dornier bomb aimers were also not averse to throwing out little appendices in the form of booby-trapped cigarette tins. De Reszke was one of the containers-of-choice, and they could be heard gently clattering down into the streets, to lie in wait by drain covers, cobbles and leaf-filled gutters until an unsuspecting passer-by levered the lid off in the hope of finding a few free cigarettes.

**I searched the sand for Famous
Cricketers...
...happy at being on my own**
To the Sea Philip Larkin

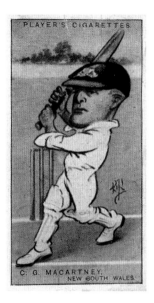

Ján Ludvik Hoch was born in pre-war Czechoslovakia in 1923. Enlisting in the British Army in 1941 he fought across Europe from the Normandy beaches, after discreetly changing his name to du Maurier, the name of his cigarette of choice. Probably thinking it was somehow more English. But he later re-named himself Robert Maxwell. Yes, that Robert Maxwell. The serial pension robber who nose-dived off his yacht in 1991.

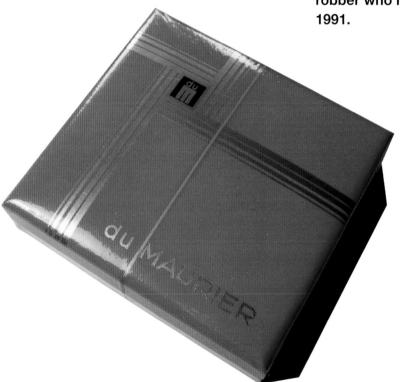

Up in the north east they get a bit tetchy about Nelson. They reckon their local hero Admiral Collingwood had as much to do with victory at Trafalgar as the one-armed, one-eyed hero who stares down from his London column. Probably more, they say. Low north east sales figures for newly-launched Nelson cigarettes mystified the sales office until they were enlightened, but we still never saw twenty Collingwoods next to the Newcastle Brown bottle.

Menu

NELS

TIPPED CIG

When I used to hang out in pubs I would show people the front of my Camel cigarettes. "If you were marooned here, in the desert, where would you sleep?" I'd ask them. "Under that palm tree, by that pyramid, or curled around the legs of that camel?" They would think for a while and pick one or other, whereupon I'd crow, "That's a foolish choice, because just around the corner…" I'd turn the packet over to display the mini Topkapi Palace on the back "…is an excellent hotel."

Will Self / *The Independent* 11 June 2005

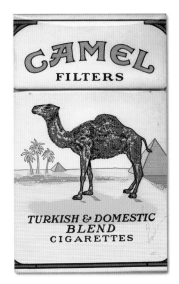

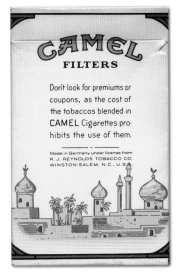

My mother smoked two Craven As, one on Christmas morning and another at 10 past midnight on New Year's Eve. Once only, she lit up after the Christmas pudding, but that was because her brother, staggering down the path, left after a flaming row to do with investments. Beryl Bainbridge / *Guardian* 14 May 2007

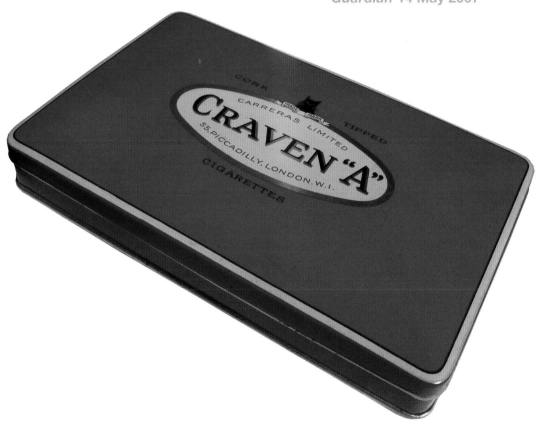

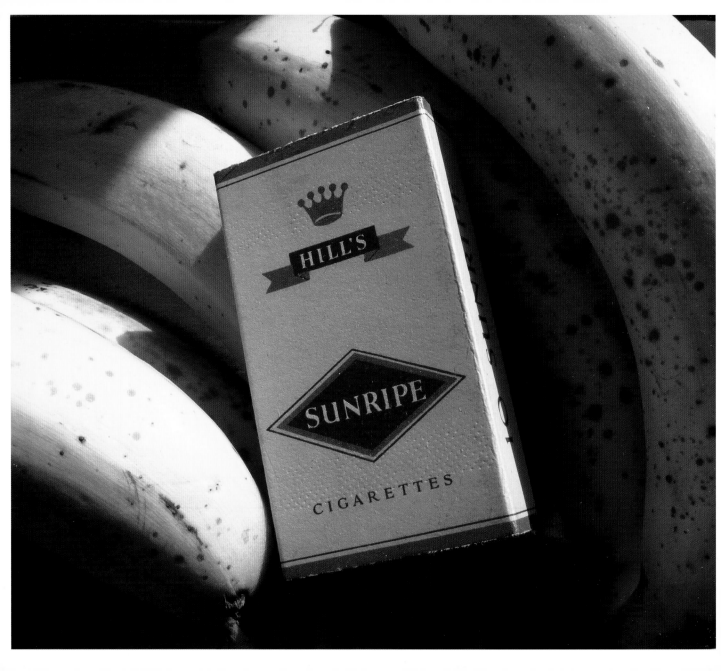

In 1942 Maurice Newey was made a prisoner-of-war in Italy. Campo 54 was at Fara Sabina in the Sabine Hills north of Rome, and here Maurice kept a notebook that is now in the Imperial War Museum. On 1July 1943 he wrote "Gloom is everywhere except in P.O.W. Camps, where we are all in high spirits, because we know our lads will soon be here to release us... Received parcel of 200 Sunripe cigarettes from R&J Hill Ltd, 66 Great Eastern Street, London EC2. More than likely the first parcel of Sunripe came from them too..." I love the fact that Maurice spelled-out Hill's address in full, and that a manufacturer got directly involved in sending out these essential comforts.

Craven A were named after the third Earl of Craven and were the fag-of-choice for Muhammad Ali Jinnah, the founder of modern day Pakistan. He got through fifty a day, presumably believing the Craven A advertising slogan: 'Will Not Affect Your Throat'. He eventually contracted tuberculosis.

Softly croons the radiogram, loudly hoots the owls,
Judy gives the door a slam and goes to feed the fowls.
Marty rolls a Craven A around her ruby lips
And runs her yellow fingers down her corduroyded hips...

Invasion Exercise on the Poultry Farm
John Betjeman

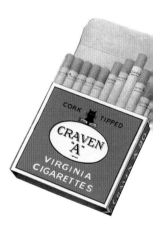

"Ah, you don't know! My one true love! The man of my dreams. The sailor on the front of the packet of Players. You have never thought about him as I have." She came closer to him on the banquette and held the packet under his eyes. "You don't understand the romance of this wonderful picture – one of the great masterpieces of the world. This man," she pointed, "was the first man I ever sinned with. I took him into the woods, I loved him in the dormitory, I spent nearly all my pocket money on him. In exchange, he introduced me to the world outside the Cheltenham Ladies College..."

Thunderball Ian Fleming 1961

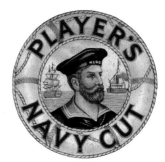

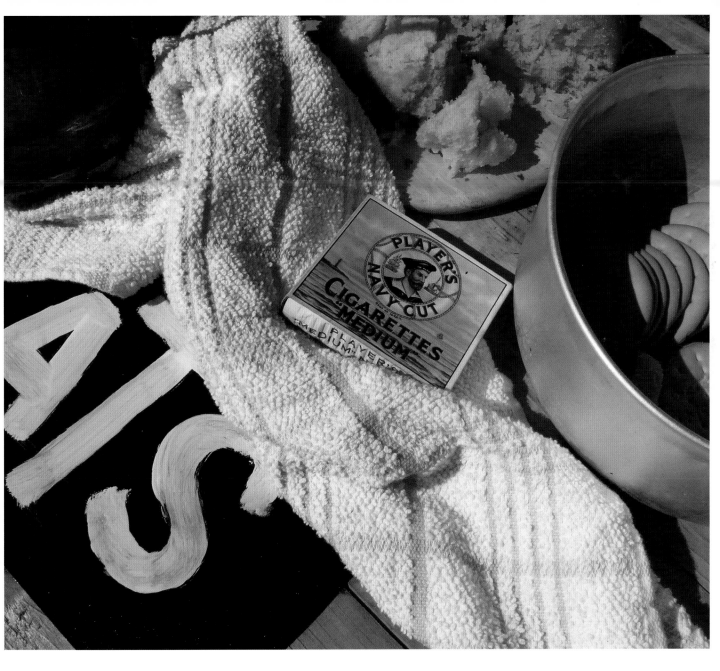

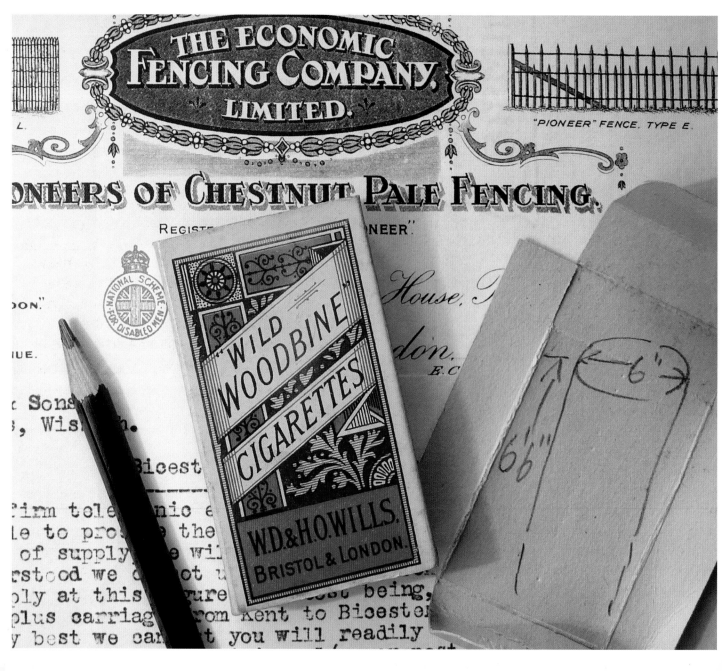

My cousin's husband once worked for the Electricity Board out on the Cambridgeshire Fens. Come the 1978 floods in Wisbech he was despatched to put in new meters on a pre-war council estate built, of course, on the floodplain of the River Nene. Each meter was timed to take half-an-hour or so to replace, but one took a giant screwdriver, whole cans of WD40 and an hour just to remove it from the wall. As the last bolt slowly came out, a flattened Woodbine packet dropped to the floor of the understairs cubby hole. On the back was a scribbled inscription: "That was a right bastard, wasn't it mate?" Forty years for the joke to see the light of day.

Introduced by Carreras in 1960, this was one of the packs that spearheaded the headlong rush into clinical stripes and bland geometrics. But this was a classic. Now of course the bearskinned soldier would have to hide under the counter like a commando on a covert mission, planned, we hope, with the help of the indefatigable Player's sailor from HMS Hero. Guards were sold to sixties cinema audiences with a superb widescreen commercial that pounced on the ceremonial possibilities.
A multiscreen of vertical frames of civilians flipped on a horizontal axis, turning them into images of marching guardsmen. All cut, of course, to a rousing drum-beating score of something like The British Grenadier. A caption came up at the end that said "People are changing to Guards".

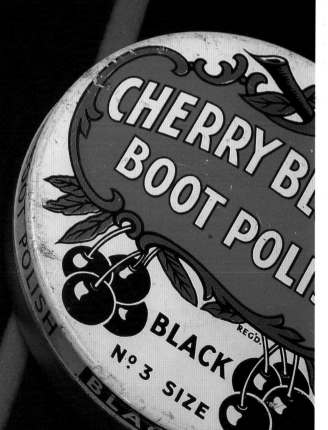

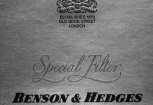

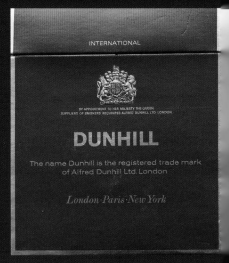

CONSULATE

Menthol Fresh

KING SIZE FILTER TIPPED

INTERNATIONAL

DUNHILL

The name Dunhill is the registered trade mark
of Alfred Dunhill Ltd. London

London·Paris·New York

Special Filter

BENSON & HEDGES

ESTABLISHED 1873
OLD BOND STREET
LONDON

The mild cigarette

GALLAHER LIMITED

20 FILTER

John Player Special
KING SIZE

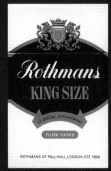

Rothmans
KING SIZE

BY SPECIAL APPOINTMENT

FILTER TIPPED

ROTHMANS OF PALL MALL, LONDON, EST. 1890

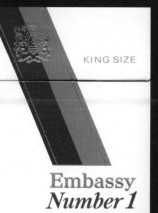

KING SIZE

Embassy
Number 1

Harrods

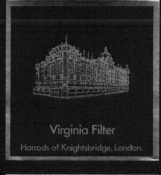

Virginia Filter

Harrods of Knightsbridge, London.

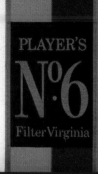

PLAYER'S

N°6

Filter Virginia

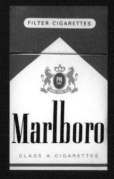

FILTER CIGARETTES

Marlboro

CLASS A CIGARETTES

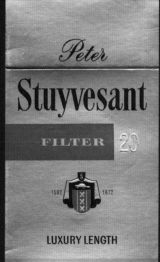

Peter

Stuyvesant

FILTER 20

1582 1672

LUXURY LENGTH

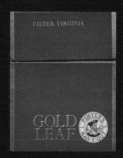

FILTER VIRGINIA

GOLD
LEAF

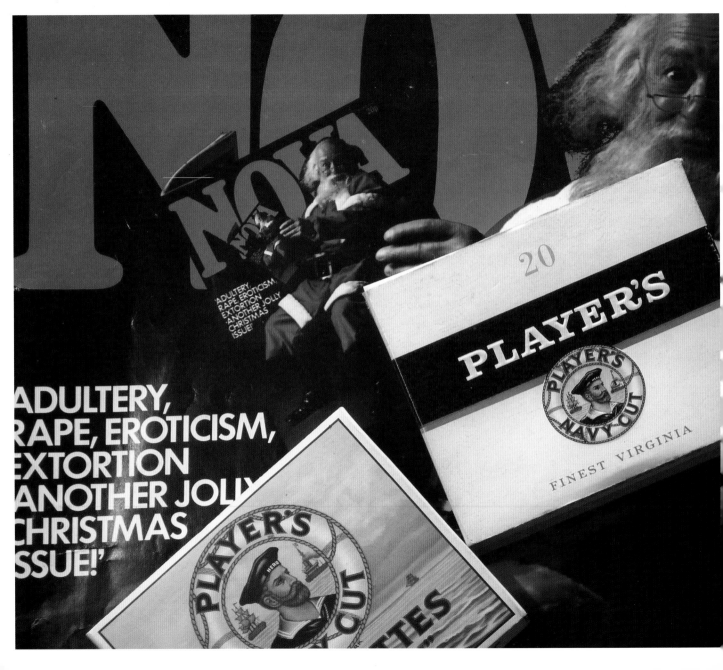

In January 1973 the brilliant and sadly lamented *Nova* magazine launched their 'Save-A-Pack' campaign. Readers were implored to recognise the value of the packaging of such iconic brands as Lyle's Golden Syrup, Mars Bars, Lea & Perrin's Worcestershire Sauce and Brasso. You could cut out a badge (designed by Mike Farrell) to demonstrate your allegiance to a particular pack, but sadly, as writer Janet Fitch bemoaned, Player's had already stripped (and striped) their flagship brand down to bare, somewhat sterile, essentials. And as she so presciently said: "It is hard to distinguish one new cigarette pack from another…" Amazingly, after forty-odd years, all the packs Janet championed have more or less survived intact. Some even got better.

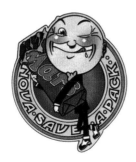
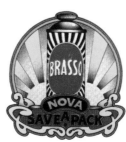

We don't hear the word 'bachelor' much these days. The dictionary definition being 'an unmarried man', I always wondered about the silhouette of the woman on the pack. Surely Player's weren't suggesting that the man was facing away from all things feminine. Mind you, when designer Robert Brownjohn (*Goldfinger* film titles) conceived a new pack in 1961, simply showing the cigarettes as if the carton wasn't there, it didn't help his cause when he presented them to Player's with tampons in the packs instead of cigarettes.

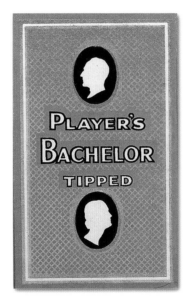

At Horsted Keynes they like their greens
Of Southern Railway fable,
But tender blokes they like their smokes
Of Wills Woodbine Red Label.

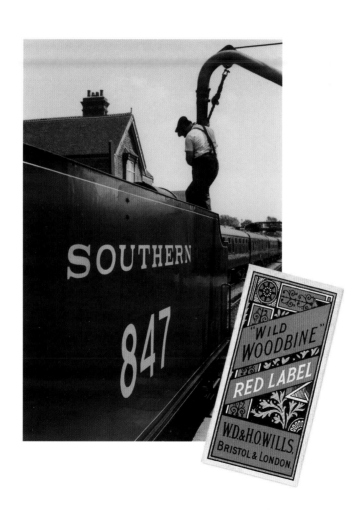

Here endeth the packet. I hope you've enjoyed this tour of the tobacconist's shelves, the rummage in the forgotten pockets, the reminders of how we were and how one of life's most ubiquitous pleasures was presented to us in such a pleasing way. Without lecturing us, without a patronising shake of the head, without the Tobacco Police fingering our collars. We will never see you again old friends.

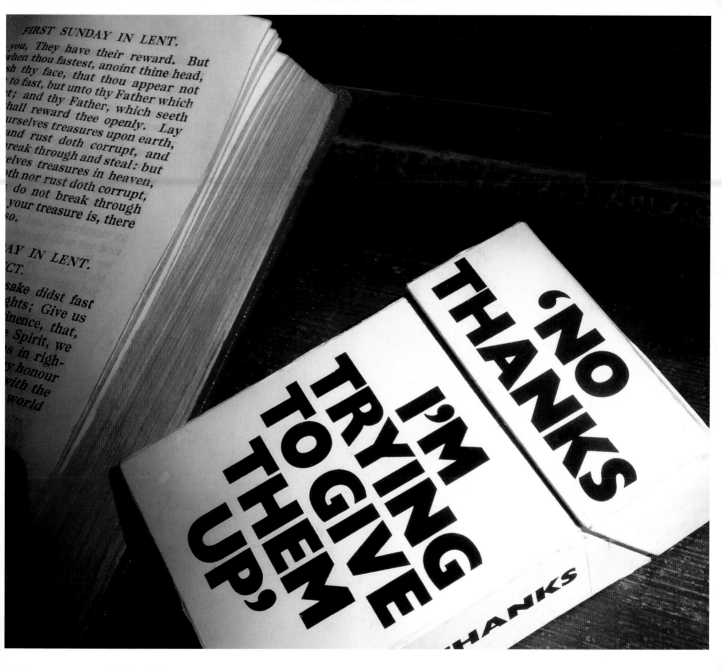

Acknowledgements Thanks to Mike Goldmark for his unfailing support of this project, and to Frank Harper for giving me generous access to his collections of packets and cigarette cards. Thanks also to: Lucy Bland, Christopher Clarke, Teresa Cox, Jon Dudley, Denny Einav, Rupert Farnsworth, Jamie Farrell, Jay Goldmark, Richard Gregory, Leigh Hooper, Susan Imgrund, Roger Porter, Biff Raven-Hill, Lilian Sampson, Toby Savage, Dave Simons, Christian Soro, Hazel & Ken Wallace, Philip Wilkinson. I am also grateful to commentators who have followed this project on my blog (unmitigatedengland.blogspot.com) and who have made useful suggestions, and to the 'ATS' girls at English Heritage's annual Festival of History who allowed me to skim a Player's packet onto their cake table.

Bibliography Only one book covers this vast subject with anything approaching insight and scholarship: *Cigarette Pack Art* by Chris Mullen, (Hamlyn 1979). Also worth seeking out are the individual volumes of Robert Opie's Scrapbooks, all of which contain pages of cigarette packets from the Victorian to those of the 1970s.

Apart from the novels and collections of poetry, I also gleaned useful snippets from these books: *Echoes of the Great War*: The Diary of the Reverend Andrew Clark, 1914-19 (Oxford 1988); *How It Was In The War* edited by Godfrey Smith (Pavilion 1989); *Robert Brownjohn: Sex & Typography* / Emily King (Princeton Architectural Press 2005).

Most of the illustrations in this book are from the author's personal collections. Others have come from various sources, as listed below.

For the illustrations and text on the following pages the author and publisher would like to credit:

Title Page Illustration by Fougasse from *Family Group*, published by Methuen, 1944. Reprinted by kind permission of Punch Limited, www.punch.co.uk.

p.13 Illustrations by Joyce Dennys from *Our Hospital ABC*, John Lane the Bodley Head c1916. Verses by Hampden Gordon & M.C.Tindall.

p.14 Extract from *A Glastonbury Romance* by John Cowper Powys, John Lane the Bodley Head, 1933.

p.26 Extract from *Delectable Duchy* by Sir John Betjeman, © The Estate of John Betjeman. Reproduced by kind permission of John Murray (Publishers) Ltd.

p.29 Extract from *The Ipcress File* by Len Deighton, Hodder and Stoughton, 1962.

p.30 Extract from *Brighton Rock* by Graham Greene, 1938, © The Estate of Graham Greene. Reproduced by kind permission of David Higham.

p.42 Extract from THE SPY WHO LOVED ME, © Ian Fleming Publications 1962. Reproduced with permission of Ian Fleming Publications Ltd, London, www.ianfleming.com.

p.43 Extract from *The Ipcress File* by Len Deighton, Hodder and Stoughton, 1962.

p.53 Extract from *The Heart of London* by Monica Dickens, reprinted by permission of Peters, Fraser & Dunlop, www.pfd.co.uk, on behalf of the Estate of Monica Dickens.

p.54 Extract from *Billy Liar* by Keith Waterhouse, 1959, published by Penguin, © The Estate of Keith Waterhouse. Reproduced by kind permission of David Higham.

p.55 Penguin book cover design by Tony Meeuwissen.

p.62 Extract from *An Innkeeper's Diary* by John Fothergill, 1931. Reproduced by kind permission of Faber & Faber Ltd.

p.67 Extract from *John Betjeman Letters Volume One: 1926-1951*. Edited and Introduced by Candida Lycett Green, 1994. Reproduced by kind permission of Methuen.

p.82 Extract from *Pot Pourri in a Surrey Garden*, John Betjeman,

© The Estate of John Betjeman. Reproduced by kind permission of John Murray (Publishers) Ltd.

p.86 Extract from *To the Sea* taken from *High Windows*, © The Estate of Philip Larkin. Reproduced by kind permission of Faber & Faber Ltd.

p.90 Extract from article by Will Self / The Independent, 11 June 2005. Reproduced by kind permission of Will Self.

p.91 Extract from article by Beryl Bainbridge /Guardian, 14th May 2007, © Guardian News & Media Ltd, 2007.

p.94 Illustration from *Britannia and Eve*, August 1947.

p.95 Extract from *Invasion Exercise on the Poultry Farm* by John Betjeman, © The Estate of John Betjeman. Reproduced by kind permission of John Murray (Publishers) Ltd.

p.95 Illustration from *Britannia and Eve*, November 1948.

p.96 Extract from THUNDERBALL, © Ian Fleming Publications Ltd, 1961. Reproduced with permission of Ian Fleming Publications Ltd, London, www.ianfleming.com.

p.108 Illustration by Fougasse, *Home Circle*, published by Methuen, 1945. Reprinted by kind permission of Punch Limited, www.punch.co.uk.

Every reasonable effort has been made to contact copyright holders of material reproduced in this book. Any omissions are entirely unintentional and should be notified to the publisher, who would be glad to hear from them and will ensure corrections are included in any reprints.

Peter Ashley is the author and photographer of over twenty books, including *Unmitigated England* and *More from Unmitigated England*. He edited *Railway Rhymes* for the Everyman's Library Pocket Poets Series and collaborated with Philip Wilkinson on books accompanying the BBC Restoration programmes, as well as *The English Buildings Book*, the ultimate guide to building types. Recent years have seen *Built for Britain: From Bridges to Beach Huts* (2009), followed by *Cross Country* (2011).